sunglasses

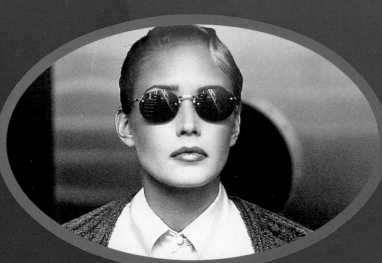

HAMLYN

Editor: Mike Evans
Production Controller: Melanie Frantz
Picture Research: Wendy Gay
Art Director: Keith Martin
Design: Valerie Hawthorn

Consultant Editor: Emily Evans

First published in 1996 by Hamlyn,
an imprint of Reed Consumer Books Limited,
Michelin House, 81 Fulham Road,
London SW3 6RB
and Auckland, Melbourne, Singapore and Toronto

Previous page: glasses by Emporio Armani. Opposite: Valentino

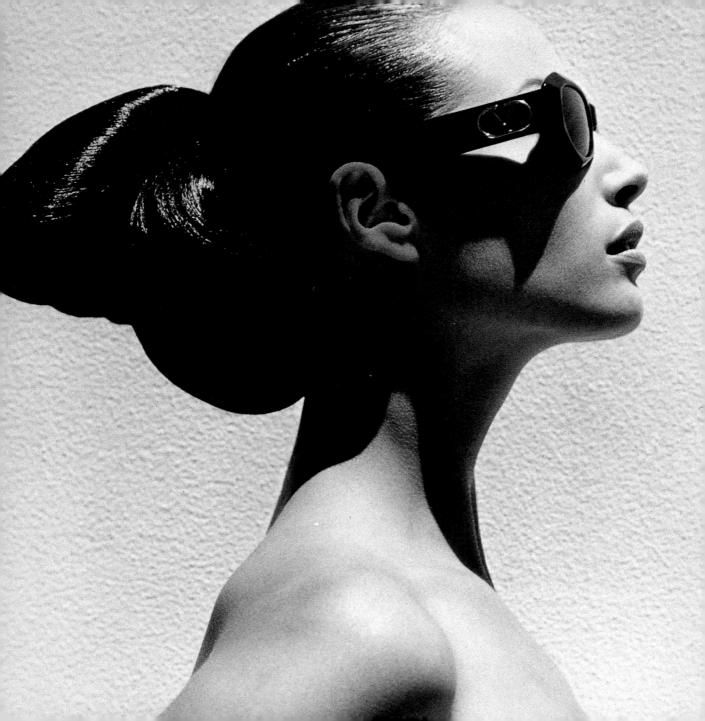

INTRODUCTION - 7 SUN & SAND - 8 INTO THE BLUE - 18 JAZZ, BOP & BEATNIKS - 22

BAD GUYS - 32 HIPPY TRIPPING - 38 GLAM - 46 SPORTSCAPE - 50 FUTURAMA - 54

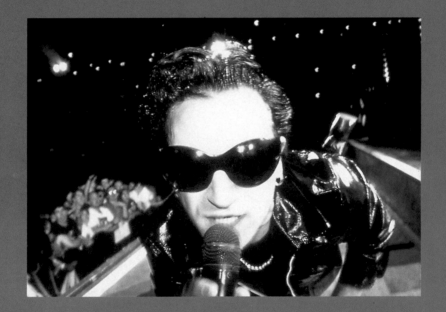

The very first sunglasses were in fact developed – as 'protective glasses' – for colder climes than those with which they were eventually associated. They were developed in the latter half of the 19th Century using coloured amber or mica for polar (was that the polar in Polaroid ?) and other expeditions likely to be exposed to the danger of snow blindness.

S U N & S A N D

'The craze for gayly colored sunglasses that swept across the country last year and is booming again with even greater fervour as summer comes on again, has revived to full capacity one of the most remarkable and least-known branches of the glass-making industry. Although tens of thousands of the familiar "smoked" and amber glasses, for beach and sporting wear, had been made and sold regularly each year, the new fad sent the demand skyrocketing to millions, while lens glass of half a dozen new tints and colors had to be created almost overnight'

Popular Science Monthly, July 1939

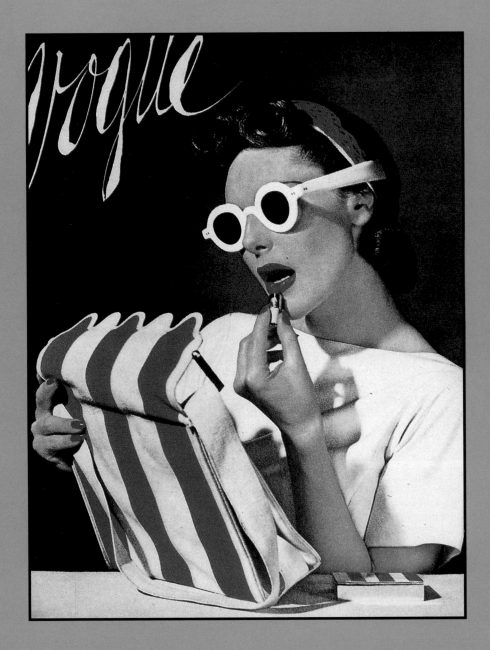

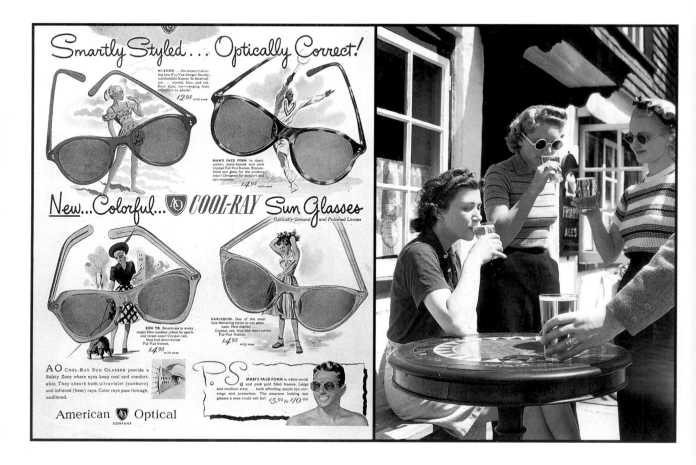

In the 30s and 40s women were getting out and about, often for the first time, away from solely domestic responsibilities – a liberation partly influenced by their role in 'male' jobs during the War – and the new-found sense of freedom expressed itself in casual fashions that included sweaters, slacks – and sunglasses.

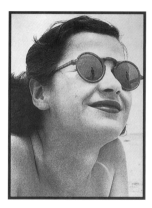

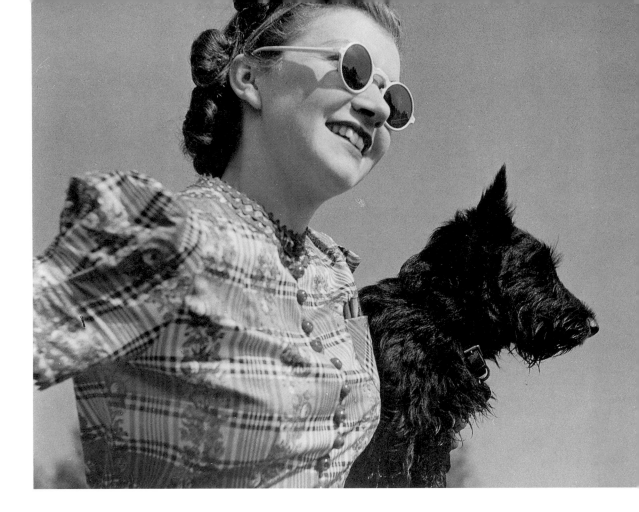

The pre-war boom in sunglasses coincided with a boom in holiday making, and the Hollywood-driven craze manifest itself in Europe and America with ordinary people in the years immediately before and after the War sporting sunglasses when on vacation, even though they would have still thought it peculiar wear for the workaday world outside leisure hours.

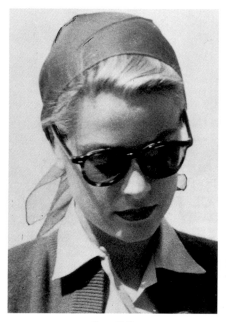

Grace Kelly

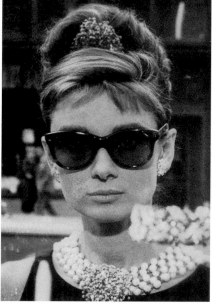

Audrey Hepburn's Holly Golightly at Tiffany's

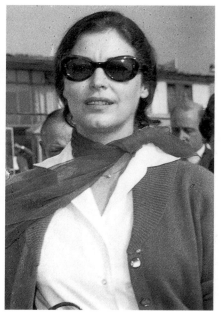

Ava Gardner

Hollywood stars like Lana Turner, Ava Gardner, the
ultra cool Grace Kelly and so-stylish Audrey Hepburn
managed to hide behind their sunglasses and make
them a fashion statement at the same time.

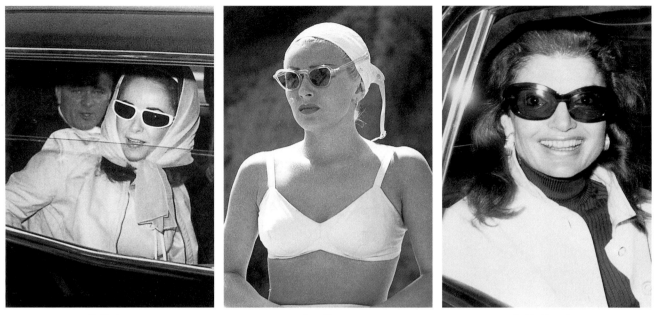

Liz Taylor Lana Turner Jackie Onassis

The rich, beautiful and famous hid behind their
sunglasses so much so that it was said that Jackie
Onassis eventually took to venturing out without
them so that she wouldn't be recognised.

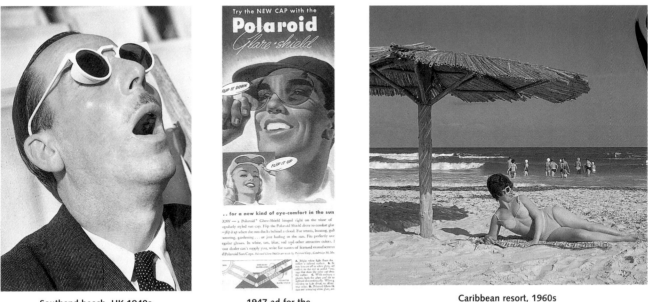

Southend beach, UK 1940s

1947 ad for the
revolutionary Sun Cap

Caribbean resort, 1960s

'Dark glasses were once the badge of the blind man. Hollywood turned them into a fad;

today they are a definite style item in avid demand by young and old. Along with plastic

frames came an avalanche of weird shapes and tints

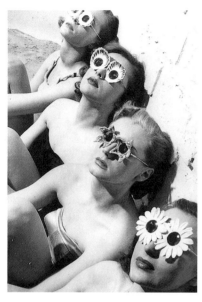

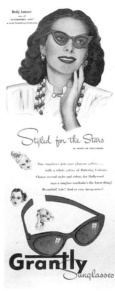

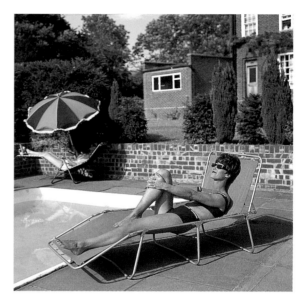

The latest lines in shades, 1957

Ad with Hedy Lamarr

Relaxing at home on the poolside lounger

. . . To be really smart, a girl must have not only the type and shade to suit her

face-shape and coloring; she requires a different pair for sports, every day, and

even – in some extreme cases of the dark glasses fad – for evening wear.

Sometimes there are individual frame designs for special costumes'

Business Week, Summer 1947

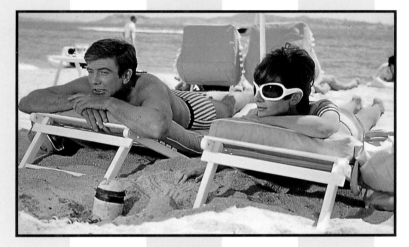

Albert Finney and Audrey Hepburn on the
beach in 'Two For The Road'

1960s Poland: For some, sunglasses would always be the stuff of
glamorous dreams, Hollywood fantasy and other peoples lives.

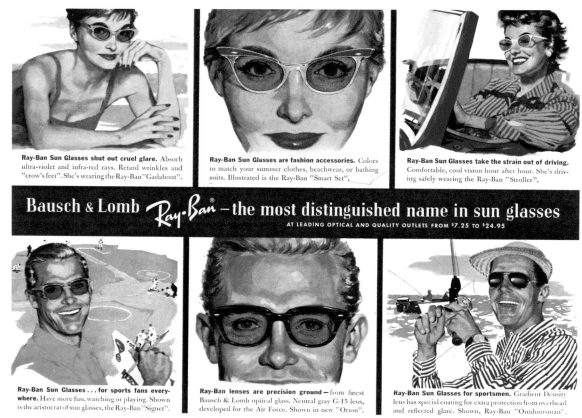

'Today, sun glasses in fancy frames are being pushed by five-and dime stores, drug stores, and department stores as well as by the special optical outlets. They retail from 25c (for grades which the scientific producers ignore) to $25 (for those having personally fitted lenses). As yet, the volume of sun glasses sales at retail amounts to a possible $18 in a total for spectacles of $250.

But sales executives say that sun glasses promotion is only in its infancy'

Business Week, Summer 1947

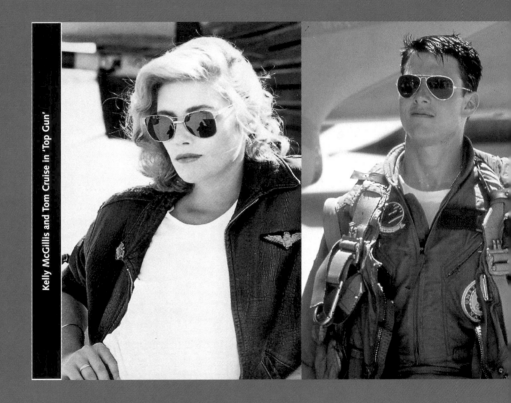

Kelly McGillis and Tom Cruise in 'Top Gun'

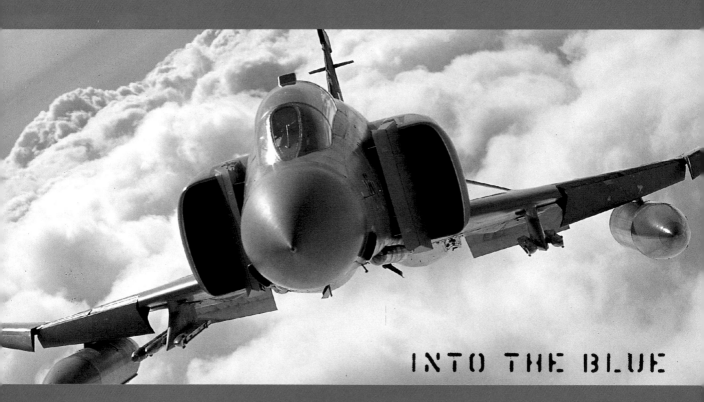

INTO THE BLUE

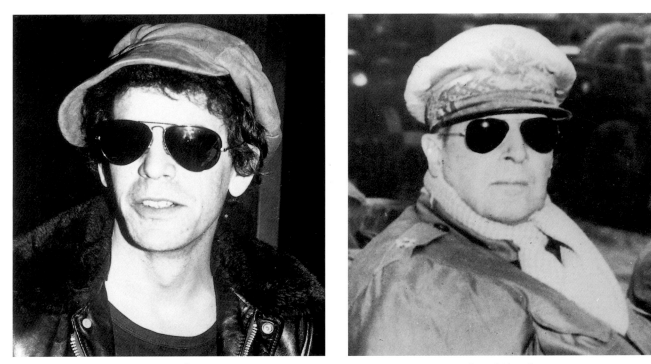

Lou Reed

General Macarthur

The American military and 'Aviator' look in sunglasses dates back to the Second World War when national figures in the fighting forces such as Patton, Eisenhower and Macarthur popularised the wire-framed shades with decidedly macho connotations. It was a look that would continue in the far-removed context of rock stars like Lou Reed and Bob Dylan.

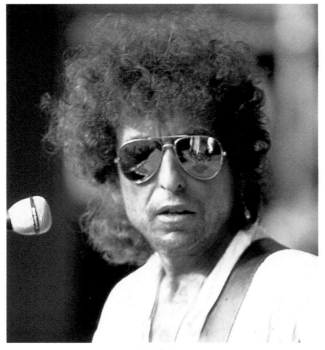

Bob Dylan

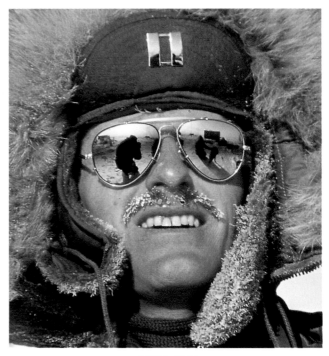

Arctic explorer

The summer of 1948 saw the debut of reflective sunglasses, usually in military-styled frames, the mirror-faced shades that not only protected the eyes more thoroughly – they reflected 30% of the suns infra-red rays – but allowed the wearer to gaze in whatever direction he or she wished, largely unbeknown to those around. A boon when being engaged by the party bore but preferring to observe someone across the other side of the room.

JAZZ, BOP & BEATNIKS

Forget the sun and ski slopes, the hippest shadeswear in the 1950s was to be found in the dark cellars of jazz clubs in New York, London, Paris, ideally at two in the morning. From the 1940s be-bop players hid behind dark glasses and gave the music a chance.

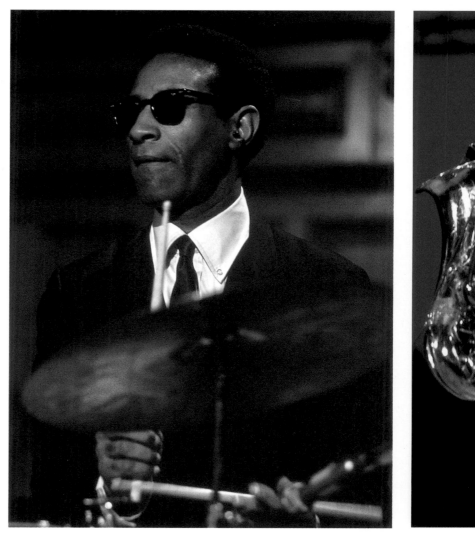

Drummer Max Roach

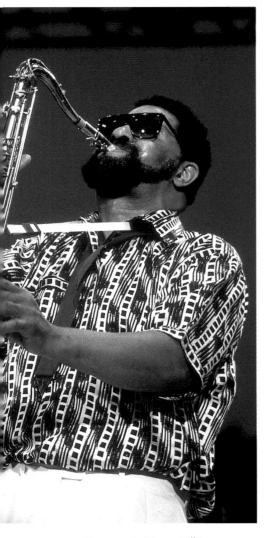

Tenor sax giant Sonny Rollins

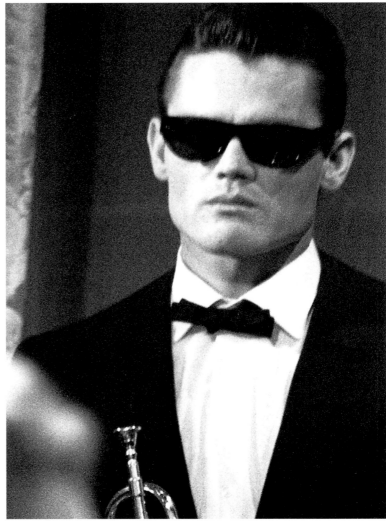

The coolest of the cool – Chet Baker

The 'beatnik' look, as dubbed by the press, was least apparent in the Beat Generation writers and poets themselves – Kerouac, Ginsberg et al – and more obvious in its admirers, from the French existentialist style epitomised by Juliette Greco, Yves Montand and the young Brigitte Bardot (left), the cult star of 'Ashes and Diamonds' the 'Polish James Dean' Zbigniev Cybulski (right), to the ill-fated Dean himself.

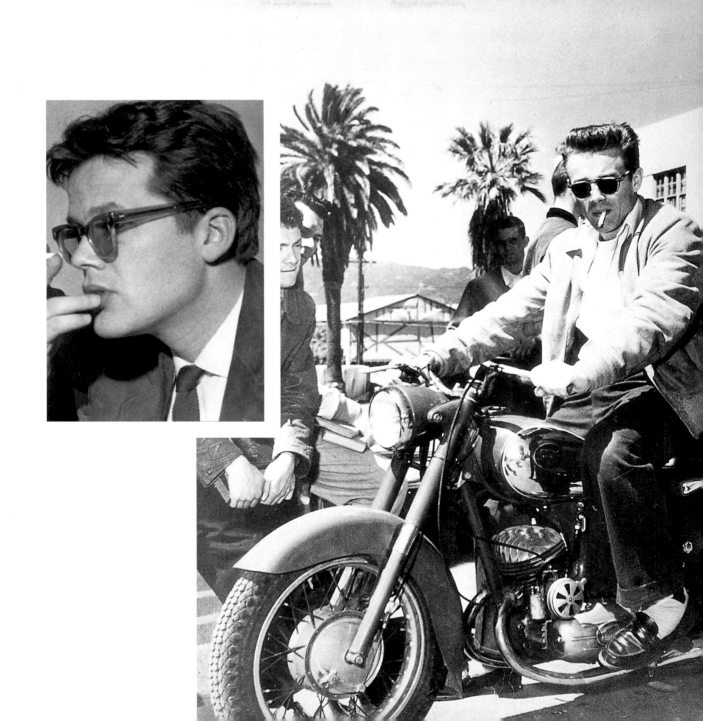

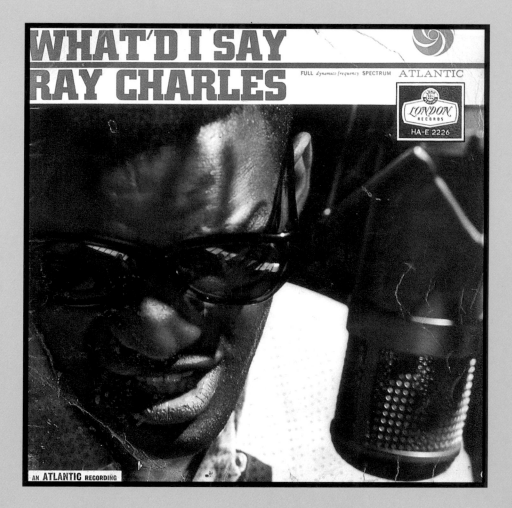

Ray Charles – dubbed 'The Genius' and the true godfather of soul – made wrap-arounds de rigueur for thousands of young fans in the late 1950s, even though he wore the style to mask the ugly ravages of glaucoma which had left him blind from the age of six.

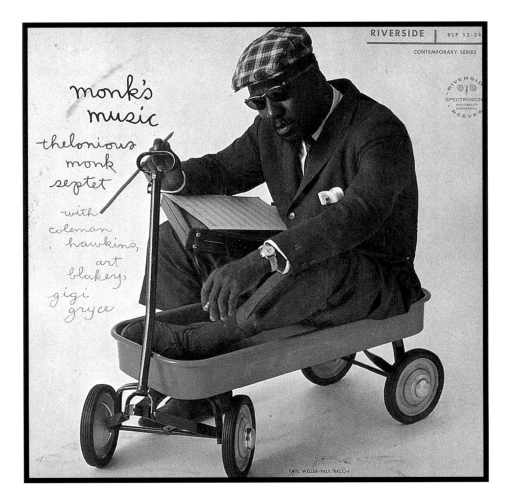

Jazz pianist Thelonius Monk was famous for his hats – from Russian fur to golfer flat caps to the standard
bop beret – and shades. The pair with bamboo frames became something of a trademark.

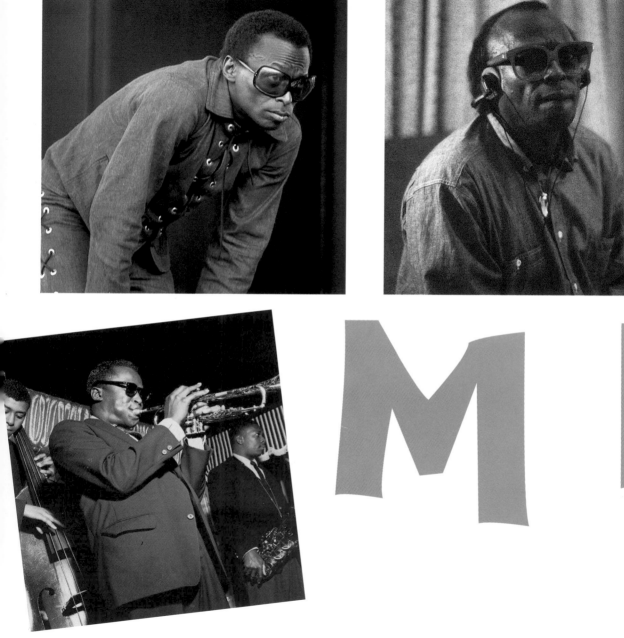

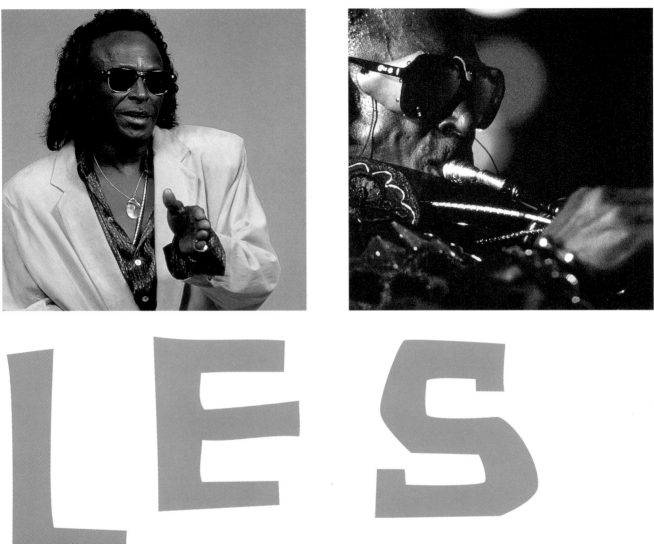

LES

Miles Davis was the archetypal jazzman-as-sharp-dresser,

and his fifty-year career at the forefront of the hippest music

could be traced in terms of the styles of shades he adopted.

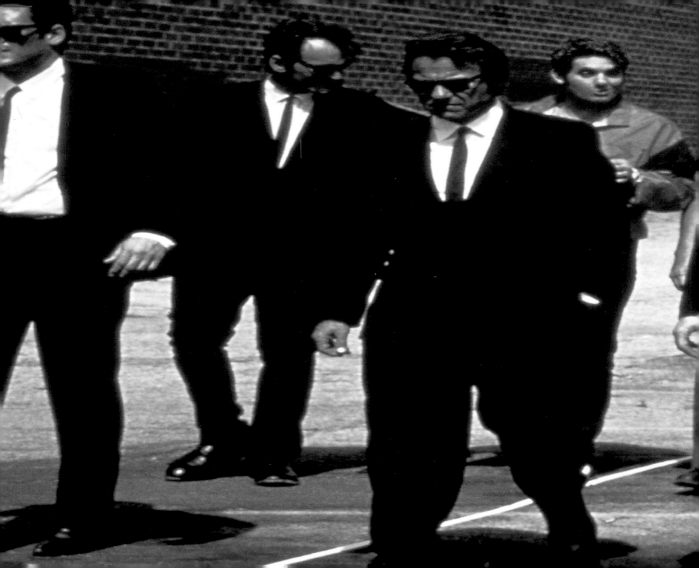

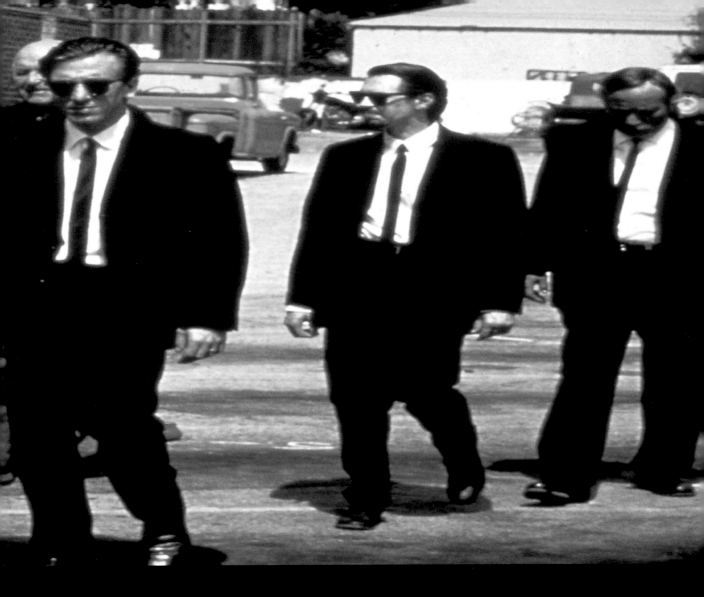

THE BAD GUYS

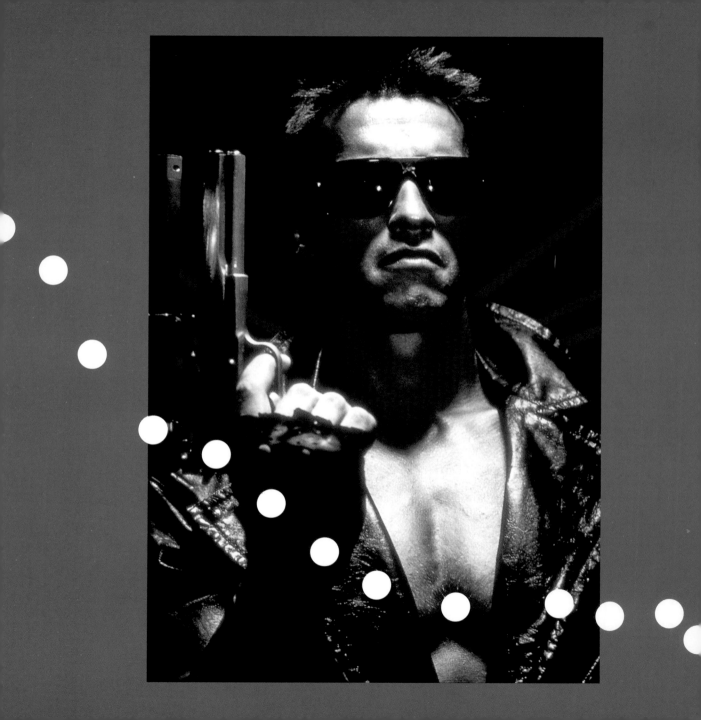

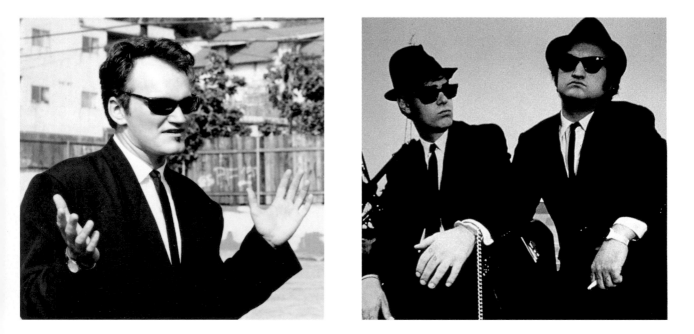

Even before Bogey donned his neat pair of sunglasses in 'The Big Sleep', dark glasses were regular wardrobe in movie thrillers, and more often than not worn by the villains. Like the cowboy-film cliché of the baddies always wearing the black hats, shades usually meant shady in pulp pictures, spy sagas and espionage epics, from 'Dirty Harry' to 'Reservoir Dogs', with the Blues Brothers thrown in for some (heavy) light relief.

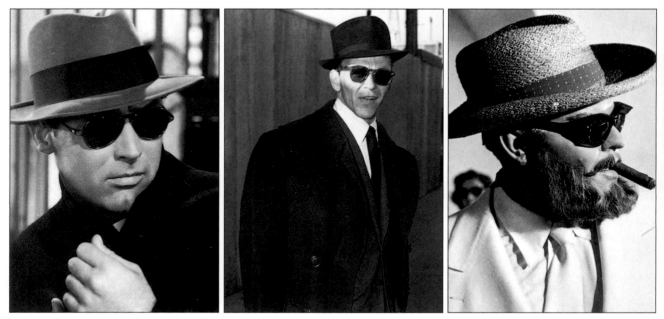

Cary Grant Frank Sinatra Orson Welles

Hats *and* shades looked like double trouble if you messed with these guys . . . and behind those visors, you just didn't know what they were thinking.
Not so, however, with Peter Sellers' 'Doctor Strangelove' (opposite) whose manic stare was as apparent as his dedication to world destruction.

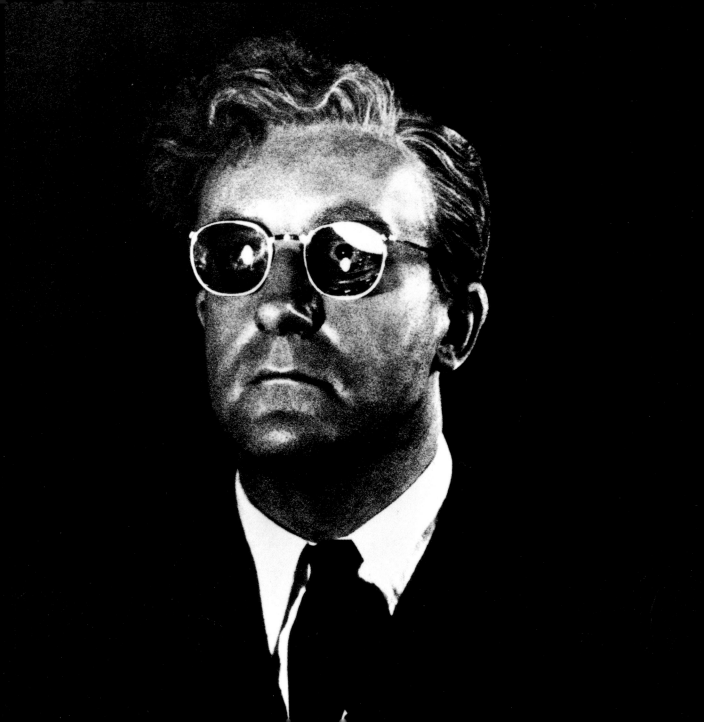

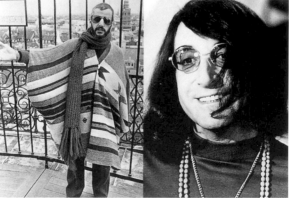

Ringo Starr Peter Sellers

HIPPY TRIPPING

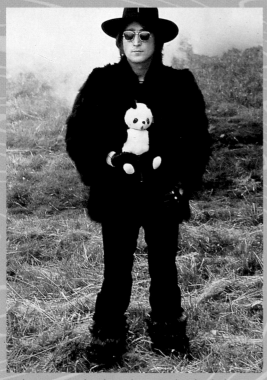

On a wave of camp nostalgia – the trendiest London boutiques had names like Lord Kitcheners Valet and Granny Takes A Trip – the swinging years of the mid Sixties saw the appearance of 'granny glasses' as a current trend. Popularised by rock stars such as John Lennon and the Byrds' Jim McGuinn, the little wire-framed specs (reminiscent of the grandmother in the Beverley Hillbillies) soon appeared with a variety of coloured lenses, encouraged by the fad for all things 'psychedelic' which literally yearned for a world seen through rose-tinted spectacles. Similarly driven by hallucinogenic stimulants, the late Eighties' Rave scene prompted a revival of the fashion .

John Lennon, and (right) with Lou Reed in the shades, New York art-rock icons The Velvet Underground

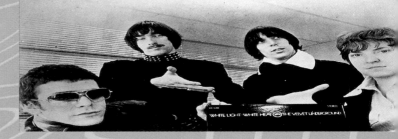

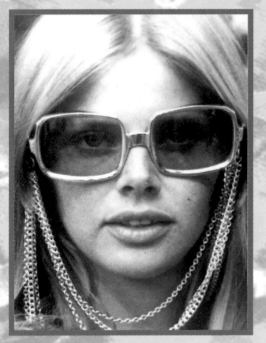

Britt Ekland

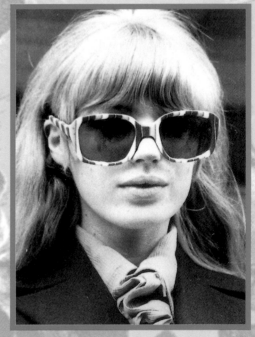

Marianne Faithfull

The 'Beautiful People' of the late Sixties Flower Power scene made sunglasses a

fashion statement as never before, and frames as well as lenses contrived to

reflect the seemingly decadent flamboyance of the period.

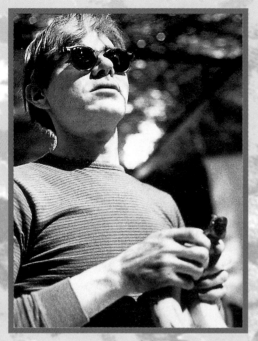

Andy Warhol

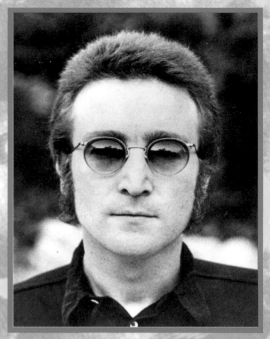

John Lennon

The gurus of the era, the influential movers and shakers of pop who were taken

seriously – for the first time in many cases – by the artistic and intellectual

cognoscenti, invariably struck an inscrutable pose behind dark lenses.

Adrienne Posta goes for the over-the-top look with her dolly bird specs. If you see what we mean.

The Sun Ain't Gonna Shine Any More for Gary Walker through these National Health type peepers!

That really is Lulu behind the green screens. We recognise her by the hair.

Here's looking at you, Sandie! This is a lady who shows real individuality at all times.

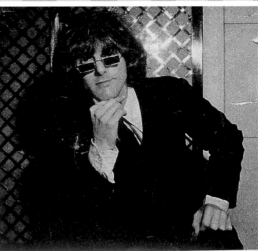

Jim McGuinn is a Byrd who doesn't believe in lowering his sights more than he needs to.

ON SPECS

The person who once said "men never make passes" obviously didn't have the foresight to realise that glasses can be the most sexy, kookie, eye-catching accessory of the lot. Depending on how you wear them, of course. In The Beat Age they're worn like this . .

Cilla pulls down the shades. She's a bit tongue-in-cheek about her optical assets.

◄ The gent on the inside looking out is Donovan. He doesn't make a spectacle of himself too often.

A Sixties teen-mag piece including Jim McGuinn of The Byrds (top right),
Donovan (bottom centre) and Cilla Black (bottom right)

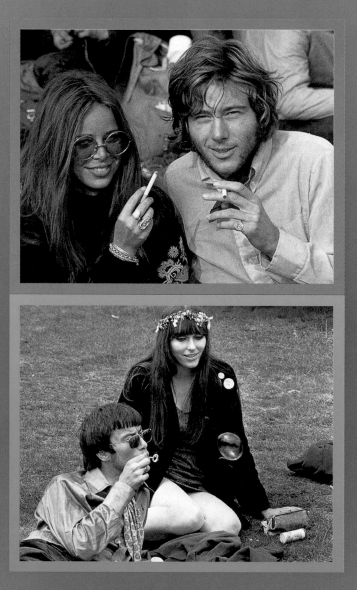

The Flower Children at play, at the 1970 Isle of Wight festival (top) and the
1967 '14 Hour Technicolour Dream' at London's Alexander Palace

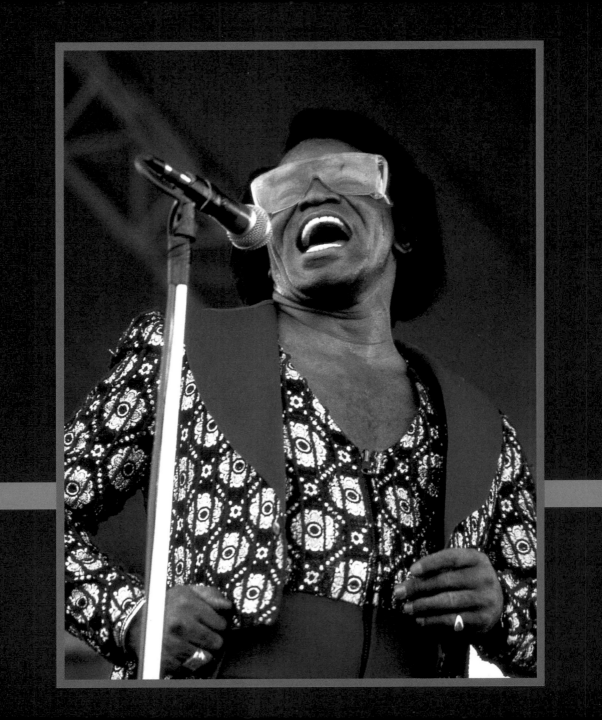

GLAM

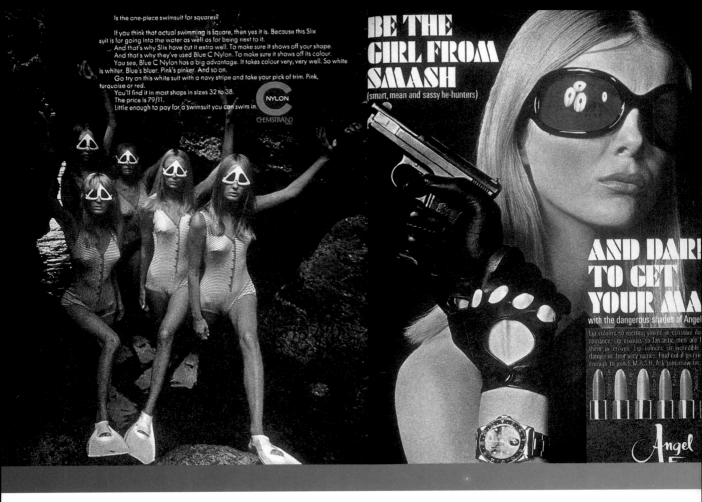

Shades had also become a staple glamour accessory by the mid Sixties, as evidenced in these two ads from the UK magazine Honey. The earlier (right) from 1966 aped James Bond and 'The Man From U.N.C.L.E', mixing macho and feminine imagery with the lipstick 'bullets'.

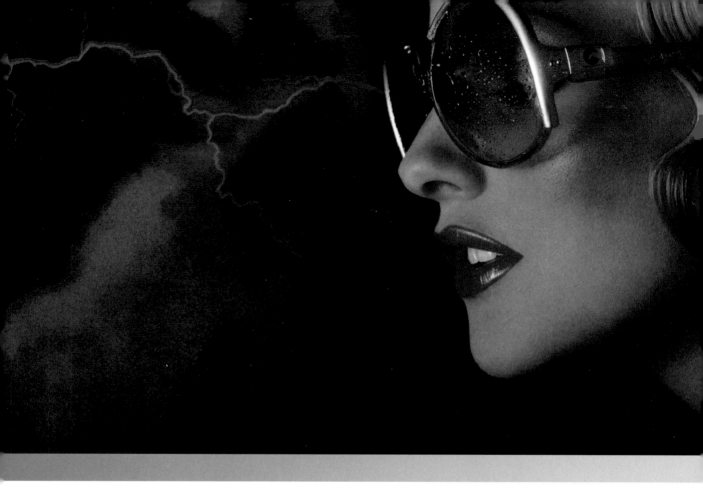

A stylish advertisement for Camargue sunglasses in the Seventies. Nobody pretends they are strictly for sun – or even outdoor – wear anymore; there might be thunder and lightning outside, but she's as safe as her lips are glossy behind her shades.

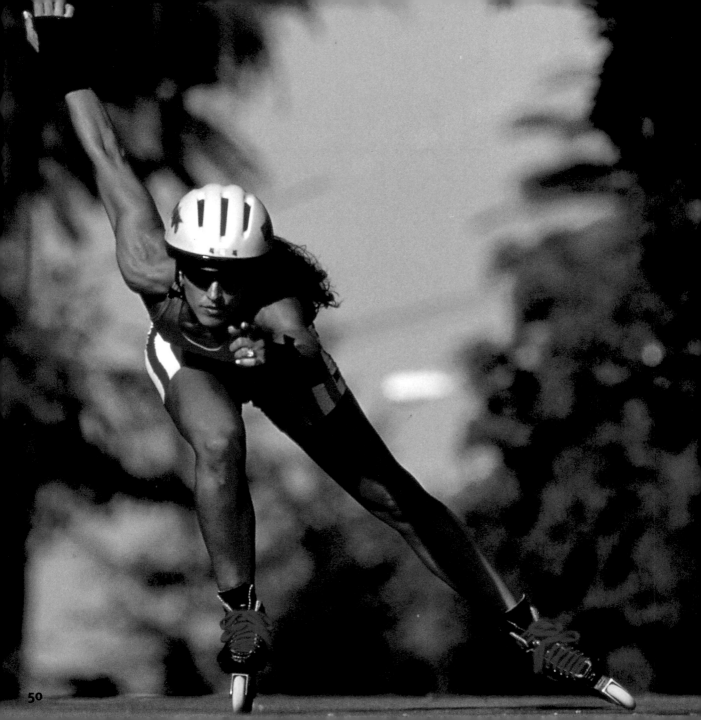

SPORTSCAPE

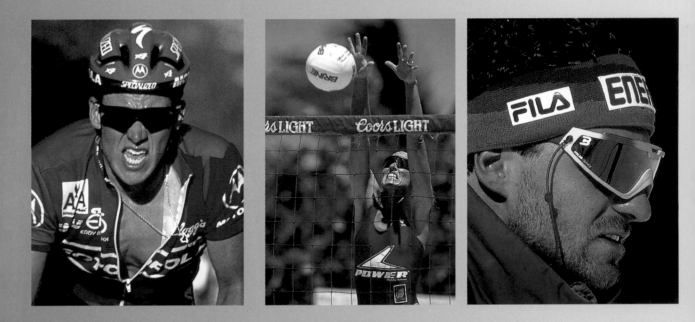

Sunglasses as sportswear can be traced back to one of their original practical functions with arctic explorers and mountaineers, transferred to the ski slopes of Europe and America by the rich and leisurly from the 1930s onwards.

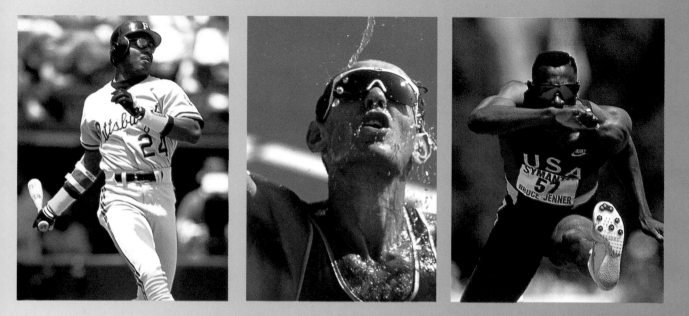

But the more obvious protection afforded skiers, cyclists and mountain climbers has spread to sunglasses being worn in sports as varied as cricket, baseball, basketball and athletics, and hugely influencing street style in the process.

FUTURAMA

Recent developments in sunglasses design, often on the couture catwalks, have ranged from the punk-influenced wrap-arounds made by Arnet (page 54) to the Barbie-doll kitsch (opposite) as modelled by Eva Herzigova

Sunglasses have become such a hot item that established designer labels such as Armani, Versace, Valentino, Byblos and Calvin Klein are vying for position at the very top end of the 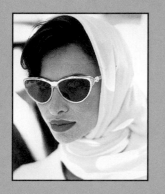 market with specific glasses manufacturers including Global, Cutler & Gross, Silhouette (inset), Oakley, Arnet, Alain Mikli and Fabris Lane.

Above and below, glasses by Silhouette with threaded sides

Naomi Campbell in Versace and (below) singer Grace Jones

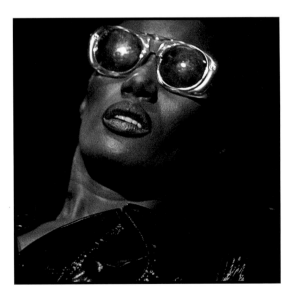

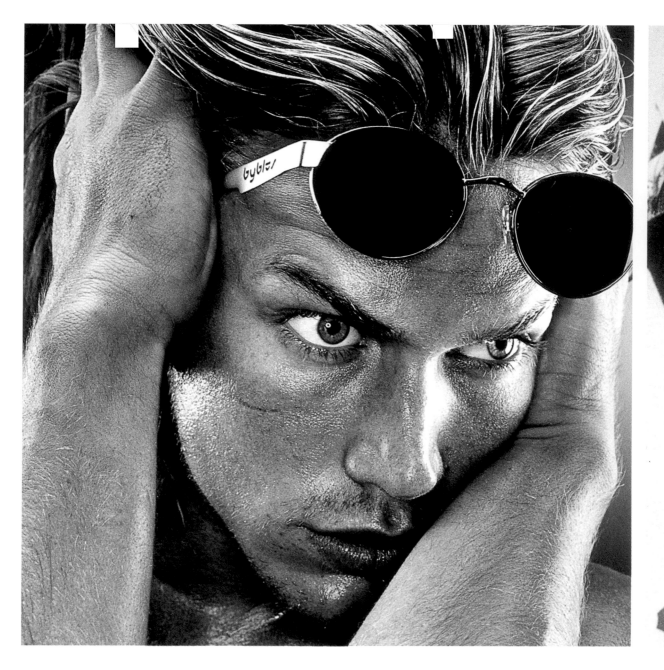

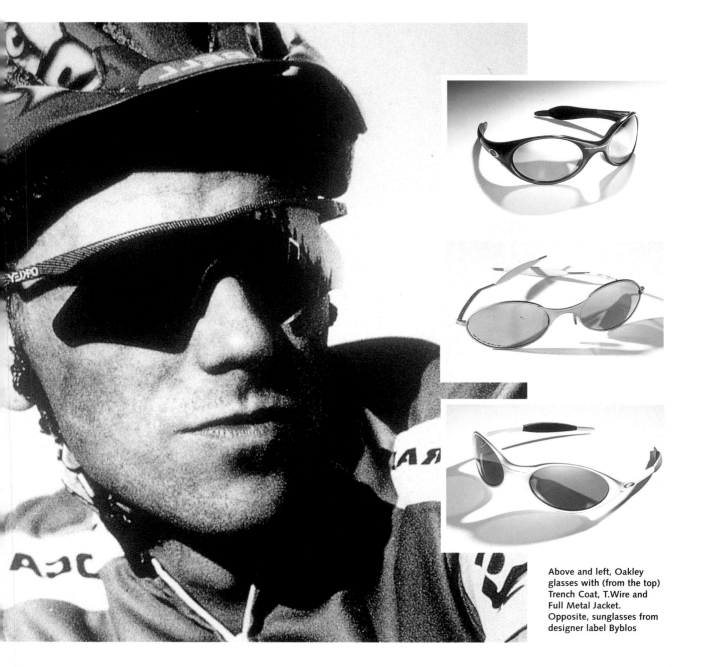

Above and left, Oakley glasses with (from the top) Trench Coat, T.Wire and Full Metal Jacket. Opposite, sunglasses from designer label Byblos

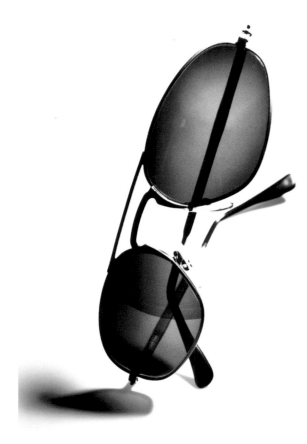

(above) High-shine frames, (below) Cats Eye

Metal Drivers

All from Fabris Lane: (below)Etalia Sports

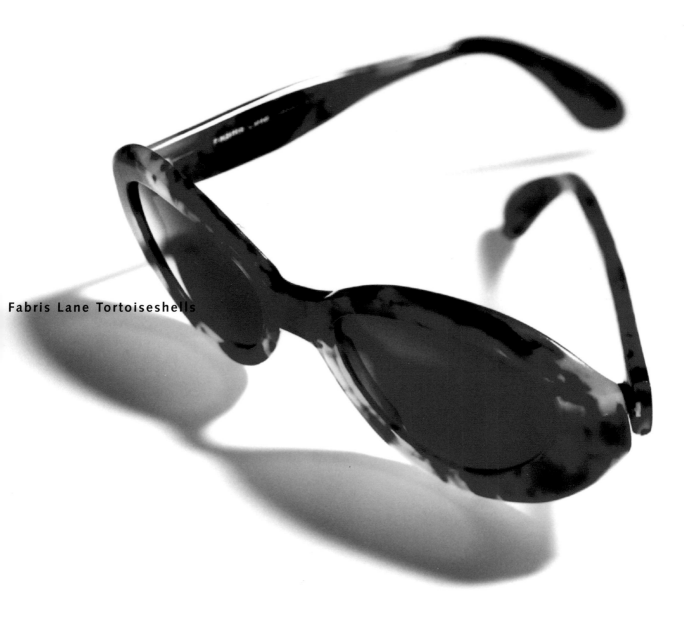

Fabris Lane Tortoiseshells

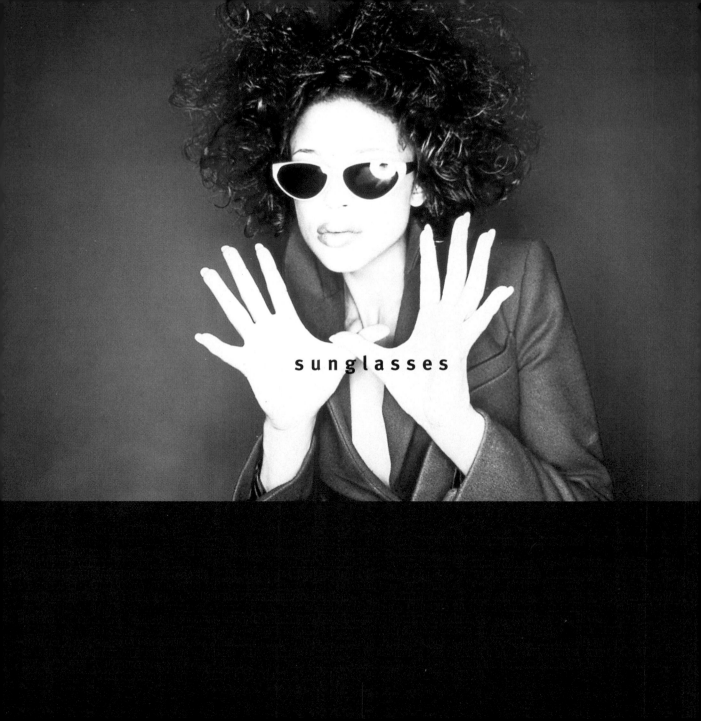

sunglasses